PORTRAIT MINIATURES BY
MOYNA FLANNIGAN

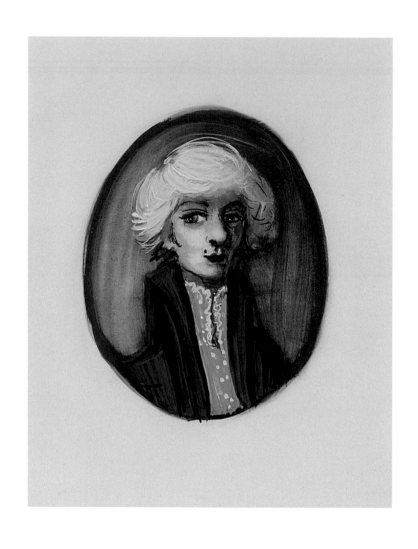

MOYNA FLANNIGAN

ONCE
UPON
OUR
TIME

With fictional cameos by Dilys Rose
and an essay by Keith Hartley

NATIONAL GALLERIES
OF SCOTLAND

Published by the Trustees of the
National Galleries of Scotland for the exhibition
Once upon our time: Portrait Miniatures by Moyna Flannigan at the
Scottish National Portrait Gallery, Edinburgh,
13 May – 5 September 2004

ISBN 1 903278 50 3

Designed and typeset in Mrs Eaves by Dalrymple
Printed in Belgium by Snoeck-Ducaju & Zoon

The portrait miniature was a highly specialised art form that flourished across Europe from the royal courts of the early sixteenth century through to the invention of photography in the mid-nineteenth century. However, by the mid-1850s the three-hundred-year-old tradition of the painted portrait miniature was spiraling into an almost terminal decline as the photographic image soon came to dominate the global market in the small-scale intimate close-up.

When it came to our notice that Moyna Flannigan – one of Scotland's leading younger painters – was thinking of creating a series of fictional portraits, in response to the historical tradition of the miniature, we were intrigued. Flannigan's new body of work, entitled *Once upon our time,* which this publication accompanies, is exhibited at the Scottish National Portrait Gallery, home to Scotland's growing collection of portrait miniatures. This is an opportunity to encourage a contemporary painter to engage with the miniature. In an era of increasing virtual reality, perhaps contemporary artists may be challenged to respond to the secret and sometimes fetishistic world of the historic portrait miniature.

The publication *Once upon our time*, which accompanies this exhibition, features a collaboration with Moyna Flannigan and the writer Dilys Rose, who has produced a series of fictional cameos. What began as a response to the images became a two-way trade, where both image and text acted as a stimulus. The

aim of the project was not to illustrate or describe each other's work, but to illuminate and add something new.

We would like to extend special thanks to Moyna Flannigan and Dilys Rose for their commitment to this unique project. Also, we wish to thank Dr Stephen Lloyd, senior curator at the Scottish National Portrait Gallery, for organising this exhibition and Keith Hartley, chief curator at the Scottish National Gallery of Modern Art, for contributing his essay. Moyna Flannigan would also like to thank Susanna Beaumont of doggerfisher gallery, Heidi Kosaniuk for the photography, Sandy Moffat, Sara Meltzer Gallery and Lynn Ahrens. We are most grateful to Whitehouse & McFadden Chartered Accountants Ltd for their support of this publication.

<div align="center">

SIR TIMOTHY CLIFFORD

Director-General, National Galleries of Scotland

JAMES HOLLOWAY

Director, Scottish National Portrait Gallery

</div>

One might have thought that the tradition of portrait miniature painting had died with the invention of photography. The idea of commissioning a small, portable painting as a memento or keepsake seems quaintly old-fashioned when you can frame a favourite snapshot or keep one in your wallet. Moyna Flannigan's miniatures, however, are not about capturing a likeness to a specific individual, nor is she concerned about working in a tradition that many consider outworn. On the contrary this is one of the things that attracts her to it. Portrait miniatures are now rarely worn either openly or hidden on one's person. Instead, they are kept in drawers or cabinets away from the light or (more seductively) behind small curtains or under protective leather flaps. This is how Flannigan first became attracted to them. In the Wallace Collection in London a number of portrait miniatures are kept in cabinets, covered with leather flaps, hidden away from the light and the haphazard gaze of passers-by. Visitors have to take the trouble to lift the flap to find out what is displayed underneath. They, therefore, have to be inquisitive and drawn towards unveiling secrets. What Flannigan discovered was a very private and often intimate world of spouses, parents, children, lovers, heroes (less often heroines), almost all belonging in their time to the top echelons of British society – images that formed part of a tradition which began in the sixteenth century. Flannigan was fascinated by what seemed to belong to a hidden, even secret, history and wondered whether she could

create her own imaginative world in similarly intimate formats.

For many years now Flannigan has been painting 'portraits' of fictional characters. These portraits are not based on real people, whether taken from life or found in magazines and newspaper photographs. Neither are they composites – someone's eyes, someone else's mouth – at least not consciously so. Rather they are an attempt to give tangible form to an idea or set of ideas. They necessarily share much with the traditional notion of the type or stock character found not only in the art of such painters as William Hogarth (1697–1764) and Jean-Antoine Watteau (1684–1721), but also in the novels of Charles Dickens and Honoré de Balzac. Here we are in the world of the commedia dell'arte and the *comédie humaine*, where traditional types – the villain, the drunk, the dissolute, the miser, the lover, the carefree spirit – are given flesh and bones and individual features that are variously caricatural, critical, parodic, playful, even pastoral. This is not the humour of jousting wit and verbal acuity; it is the earthy, often ribald humour of popular entertainment.

Flannigan connects to this tradition in her own paintings. Most of her characters look as if they might come from the professional classes. But their manners, pretentions and activities are looked at through the prism of the British music hall tradition, which since the Second World War has meant film and television comedians such as Frankie Howerd, Dick Emery, Stanley Baxter and the *Carry On* film regulars. Their high-camp humour with its outrageous double entendres, slapstick and cross-dressing is a strong element in Flannigan's work. There is even a direct nod to music hall (and perhaps to the film *The*

Entertainer) in the painting *Knucklehead* 2003 [below]. A clown-like figure, complete with cane and jauntily-worn hat, sits in the foreground eyeing an unseen rabbit whose giant shadow is cast on the cupboard behind him.

Although there is humour in this and other works by Flannigan, it is a humour with a strong tragic undertow, ultimately existential in its outlook. Many of Flannigan's figures in their strangely empty, non-descript and claustrophobic

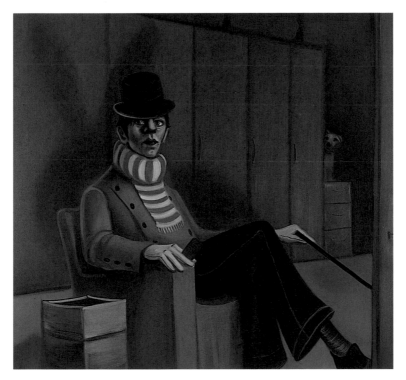

Knucklehead 2003, oil on linen, 150 × 160cm
Private collection courtesy of Sara Meltzer Gallery

interiors would not look out of place in what the critic Martin Esslin called the 'Theatre of the Absurd', in the plays of Samuel Beckett or Harold Pinter. Strongly influenced by French existentialism, this theatre rejected the naturalism of the nineteenth-century plays in which there were neatly definable reasons for human behaviour and human fate. Beckett and Pinter stressed the ultimate absurdity of existence, the lack of a universally accepted, objective meaning. As in Beckett's play *Waiting for Godot* (1952), in which Estragon and Vladimir carry on 'a music-hall dialogue against a background of nearly unalleviated despair', Flannigan's characters seem locked in an endless time warp, where nothing changes and where the only shield against total despair is a façade of humour.

How then does Flannigan arrive at her compositions? On what does she base her characters? In what sense are they portraits? If they are not based on real people or on photographs and they are not visual composites, you could say that they come out of an amalgam of memories — things seen, read, heard — which coalesce into a new fictional and painted reality. Usually the experience of one thing sparks off the memory of several other cognate, if to outward appearances, disparate experiences. Typically Flannigan's memories might consist of topical events, art historical or more broadly cultural items and aspects of popular entertainment. In trying to capture the essence of what links them all together, Flannigan 'thinks' in very painterly terms. She asks questions: What colour is this? What colour or combination of colours can convey the complex of dualities involved? Because the memories, experiences or ideas that she is

trying to coalesce are often jarring, not to say unusual, or contradictory, so the colours that she chooses might be quite jarring or discordant. Certainly, one of the first things you are aware of in looking at Flannigan's paintings is their colouring — subdued pastels, rather than strident primaries, but unexpected and electric in their offbeat harmonies rather than soothing or comfortable. They call to mind the colours of sherbet sweets one sucked as a child.

Another point to note about Flannigan's colour is that she does not use it to create a sense of space and depth in the image. The backgrounds are very often flat planes of one colour and, if a room is shown, there is little attempt to graduate the colour tonally to suggest recession. Instead, colour is applied in flat areas across the surface of the pictures. This is something that Flannigan learnt while studying for her Master of Fine Arts at Yale University in the mid-1980s. This colourist approach has been strong in the United States since the triumph of abstract expressionist painting in the 1950s when emphasis was placed on the flatness of the canvas. Pictorial depth achieved through tonal graduation was rejected; and composition, across the surface of the painting, created through the juxtaposition of colours was emphasised. Flannigan found this method of building up a painting liberating, whether she was working in an abstract or figurative idiom, because formal composition was given priority right from the earliest stages of a painting.

Interestingly, two artists who have since gone on to achieve fame internationally (and not a little notoriety) with their uncompromisingly figurative paintings studied at Yale at the same

time as Flannigan: John Currin and Lisa Yuskavage were one year ahead of Flannigan on the MFA course. In their very different ways Currin's and Yuskavage's extreme, indeed grotesque, treatment of the female nude involved them in an exploration of American popular culture every bit as arresting as Flannigan's use of British popular entertainment. There is also a similar confrontation between low and high culture: in Currin's case through his deep knowledge of the old masters, from which he borrows poses, while with Yuskavage it is through her formal painting methods and use of strong 'abstract' structures. That all three artists chose to marry high and low culture in these ways is not new. Thomas Crow in his book *Modern Art in the Common Culture* has drawn attention to the fact that artists in the modern movement since the Impressionists have often felt the need to work within and to exploit the tensions between formalist experimentation and submersion in mass culture. In particular, he has drawn attention to what he sees as the re-emergence of the genre of 'pastoral' in the modern movement. Pastoral celebrates the replacement of the gods by shepherds in rural idylls. In modern terms the shepherds have become the 'common man' and the rural idyll has become the everyday world that we know. Pastoral uses irony to remind us of our roots; it brings us down to earth. As Crow says:

> *Pastoral forms of irony within advanced art function as correctives to the congealing of professional codes of competence, to facility that too easily makes formula look like invention, to the constraints imposed by relentless high-mindedness on the breadth of human sympathy. They transform the*

limitations imposed by hierarchy and artificial division, the costs of exclu-sivity and specialised protocols, into matter for art. And the pastoral entails a final recognition that the fine arts' inability to transform themselves fur-ther, to become a genuine culture for all, remains their great and defining inadequacy. †

Flannigan's use of popular culture is no artificial posture. She grew up watching comics such as Frankie Howerd and Stanley Baxter on television. The tradition of which they are from has become part of her consciousness as it has with most people growing up in Britain since the 1960s. To allow it to inform her art, to help create her characters, part *Carry On,* part Pinter, means that she can expand the range and tenor of what she puts in her painting. Flannigan can use the humour of the vernacu-lar and popular as a way in to more serious and complicated issues or to put it the other way round, the formal qualities of her compositions and existential, even tragic, edge to her figures give depth and solidity to her comic creations. Flannigan's new use of the portrait miniature format only serves to enrich the dualities of her art. Although portrait miniatures have at times been worn openly as 'a heart on one's sleeve', they were usually private images kept hidden from public view. They bore the likeness of a loved-one and acted as a memento. However, the strongest image, and certainly the most subjective, remained within the mind of the person who commissioned or owned the miniature.

† Thomas Crow, *Modern Art in the Common Culture*, Yale University Press, New Haven and London, 1996, p.211.

Because Flannigan is creating portrait miniatures of imaginary people, she is, as it were, placing herself in the position of the putative owner. It is her subjective, mental image that she is giving form to: it is like getting a peek into the artist's mind.

Unlike most traditional miniatures Flannigan's are not painted in a sharply focused and detailed manner. They are contained within the same oval shape, and are painted with watercolour on vellum as many earlier miniatures had been, but they are loose, even impressionistic in their rendering, as if the artist were trying to capture a fleeting and imperfect memory. Because they are not images of real people, who sat for their portrait, and they are inventions of the artist, they tend to have a family likeness. Flannigan seems deliberately to be playing with the idea of an extended family, perhaps of the aristocratic types who actually commissioned miniature portraits of their nearest and dearest. The white-haired woman [page 21] with her rather haughty, disdainful expression, could easily be the mother or aunt of the lady dressed in pink [page 41]. They have the same *de haut en bas* expression in their eyes, the same rather mean, pinched mouth and the same elaborate (Mayfair-set) coiffure that never seems to go out of style among the rich and/or aristocratic. There is more than a hint about them of Barbara Cartland and her whole never-never world of a society set in champagne-flavoured aspic.

On the other hand the painting illustrated opposite represents another type of make-believe: a man dressing up to look like a woman. The very essence of drag is to try and emulate a type, whether the type is Marilyn Monroe, Liz Taylor or Judy Garland. Everything is exaggerated, formulaic and knowingly a

send-up, more of the imitator than of the imitated. He seems to
have set his sights on Liz Taylor, concentrating on Taylor's signa-
ture black hair and heavily made-up eyes. Andy Warhol did the
same in his 1963 paintings of the film star. But the character goes
over the top. The hair is too big and the eye make-up completely
dominates his thin, delicate face.

One of the key roles of the portrait miniature is an aid in
keeping someone's memory alive. This may mean that having a
likeness to look at while a person is temporarily absent, but often
a miniature was commissioned to memorialise someone who had

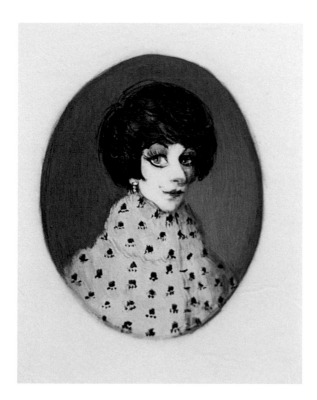

died. The painting below shows the head of what looks like a small boy apparently asleep on his bed. For someone who is presumably dead, the boy's lips are unusually red. Cot deaths are particularly distressing because apparently healthy babies die so suddenly while asleep. The healthy appearance of the boy in Flannigan's painting makes the fact that he is dead all the more poignant. Indeed, if one compares the head with similar heads of babies in Flannigan's work [page 37] it looks no different. Are these babies also dead or are they sleeping? Flannigan gives no indication either way. Infant deaths were an all too

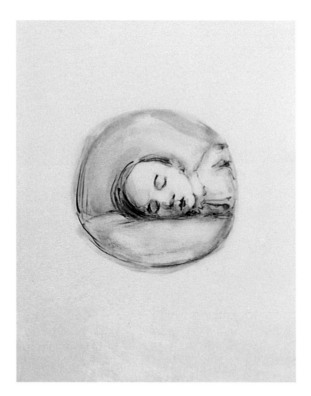

common occurrence when portrait miniatures were at their most popular. Typically, Flannigan uses a common traditional way to remember lost children in order to focus on and give perspective to a tragedy of today.

Flannigan is not, however, dealing with the deaths or lives of actual people. The characters she paints are fictions and as such can reappear in different guises and perhaps at varying ages (could the woman in grey be the older self of the pink lady?). The boy standing with arms akimbo and staring out at us in the miniature [page 23] looks remarkably similar to the boy illustrated opposite. They have similar facial features and their long lank hair is combed to the left over their high foreheads. Could they be the same boy? If so, how could the sailor boy still be alive? The answer is, in Flannigan's fictional, painted world anything is possible. She paints what might be. The mirror she holds up to our world is not a real looking glass, but the refracting mirror of her own mind, given shape by the skill of her hands and the infinite malleability of paint.

KEITH HARTLEY

PORTRAIT MINIATURES
BY MOYNA FLANNIGAN

ONCE UPON
OUR TIME

FICTIONAL CAMEOS
BY DILYS ROSE

All works are watercolour
and gouache on vellum and are
reproduced at actual size

Latterly, the only colour was her lipstick, a strong shade she'd say resembled minium, the red lead pigment mediaeval monks used in their illustrated manuscripts. Nobody ever queried the veracity of her statements. She spent her life combing the past, rummaging through tombs and vaults and middens in search of clues about how people lived theirs. Usually she turned up something. She had an eye for detail, an insatiable hunger to get her facts right – and pass them on. On the back of the portrait she'd written out, in her insect scrawl, the derivation of the word *miniature* so that we might be spared our blissful ignorance, spared from thinking, for example, that *miniature* might have the same root as *minuscule* when in fact <u>the word's association with size comes purely from usage</u>. Her italics. Her underlining.

Everything about her was small, if not always tidy. Teeth. Nails. Hands like birds' feet. Shoulders like scrawny wings. Pygmy Ice Queen. Baby albatross. Wizened snowdrop. Buttoned up to the neck as ever, but why did she have to choose that see-through blouse? And was that actually a nipple perking up through limp folds of chalky Belgian voile?

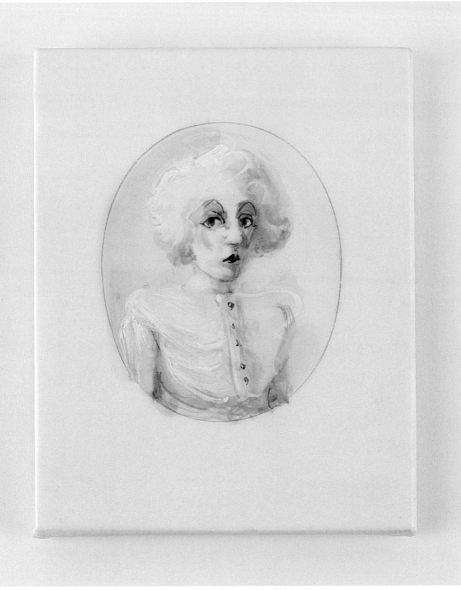

TIMOTHY

Loves himself. Can't get him away from a mirror. In the studio he goes right down the front so nobody blocks his view. Always gets a big solo in the shows too but that's because there's only him and flat-foot Torquil to choose between. We're lucky if we're seen on stage at all because there's tons of us. The boys have a whole changing-room to themselves while ours is like a total crush. When he was wee his mum made him wear tights under his shorts so he wouldn't catch cold and didn't cut his hair until he was like eight and let him play with her make-up and gave him a dressing-up box full of her old skirts and high heels and wouldn't let him play football in case he hurt himself or got bullied and didn't think there was anything weird about him wanting to watch *Riverdance* and *Billy Elliot* like a hundred times or go out guising dressed as The Lilac Fairy. But he can lift up all the girls even Gemma. And he can do higher jetés than anybody.

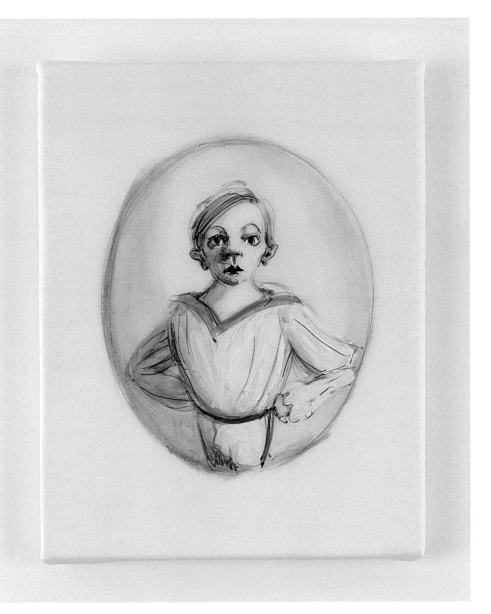

Picked up in a junk shop for a song, passed on when my parents modernised their living room, she looks at me with the same intransigence as my daughter, the same glaze of adolescence highlighting her forehead, eyelids, the tip of her nose, her lip, her chin. Pierced ears, a thin ribbon knotted at the neck, the low cut collar of her dress emphasising the swell of budding breasts. Insolent, sullen, bored, or simply absenting herself from the undrawn place where she sits?

The frame is chipped, flaking, the glass greasy. Experts warned against cleaning in case, in the process, I ruined her: the chalk and the glass had already spent two hundred and thirty years rubbing along nicely; it might be a tricky business to prise them apart.

The question is: When I'm old and my daughter is middle-aged and it's time to pass things on, should I have my girl restored or let her be, luminous and grubby?

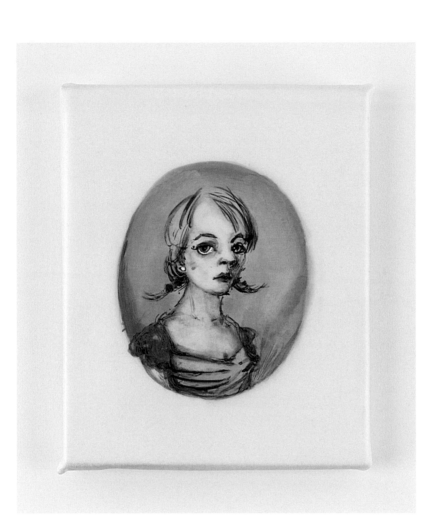

I know what you're thinking: Why bother? Nothing I do would make any difference, nothing persuade you to look longer than a blink, a twitch of your caterpillar brows, nothing in a month of hysterical, debauched Sundays make you consider considering me in a new light. In any kind of light at all.

The streetlamp on the corner's blown, by the way. You should report it to the Council, or the Neighbourhood Watch lynch mob that holes up in your bit. A pool of darkness on an otherwise illuminated street, an oasis of midnight blue in a desert of demure tenements, it can attract all kinds of undesirables. Vermin, you might say.

No absinthe-green geckos scuttling around here, gulping down black widow spiders, more's the pity. Just the odd rat, and me, my cherry stilettos skiting off greasy setts as I wend my way home: alone, again. But you know, there are worse things.

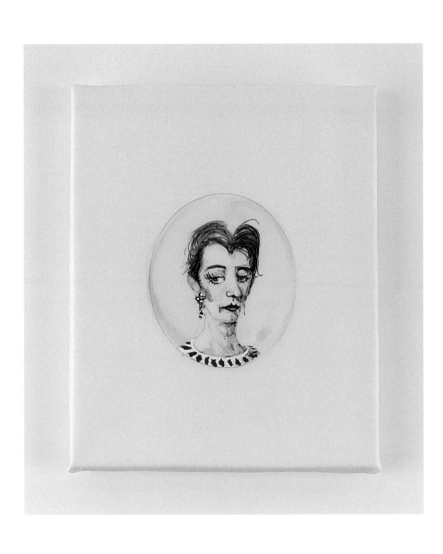

Isn't he beautiful? Don't you love that charcoal curve from the buttock to the back of the knee? Can one ever have too many nudes? What do you think Bacon was up to, painting all those Popes? Don't you think a limner is closer to God than anyone? Did you like my favourite waiter? Would you care to listen to some Bach? Preludes or fugues? Does it matter at all that we missed the party? Should I open another bottle? Red or white? Do you have to smoke? Weren't you just a little relieved? Shall we take our drinks out to the roof garden? Are you warm enough? Should I fetch blankets? Is my ficus poorly? Were you sure he'd show up? Isn't this the best view in the city? What time is your train? Do you require breakfast? Will you be miserable tomorrow? Didn't we have a good time?

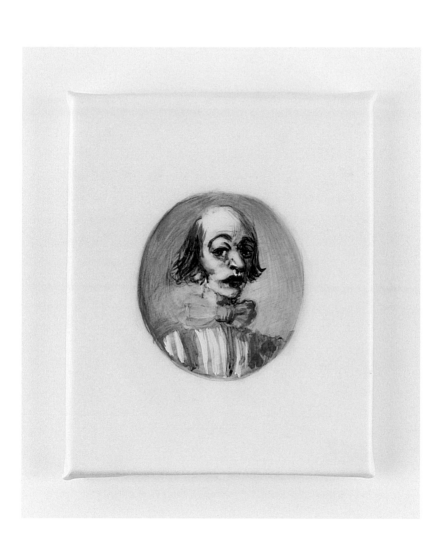

If another red-nosed dipso drawls in my ear *Here's looking at you, kid*, I will personally see to it that he won't be looking at anything for some time. As for slurring *Play it again, Sam* across the counter, I will take great pleasure in plucking out his tongue with the tweezers I use to extract bones from badly-filleted salmon. Do they really think it's a compliment to be compared to an actress who had her day when she was what, nineteen? So she's still making movie appearances as a seventy-something icon. I'm still packing them in to The Blue Parrot café, thank you very much. (If you don't get the reference, check out the movie.) Somebody's got to keep up appearances around here. Don't think I've got one of those silly control complexes; I'm not getting any younger, some of the customers leave a lot to be desired and, frankly, so do my nearest and dearest. Given the opportunity, I'd have been off long ago to Nice or some ritzy little principality, somewhere a damn sight more chi-chi than Casa-bloody-blanca to conduct my tragic affairs. Christ, I could do with a cigarette, a stiff gin.

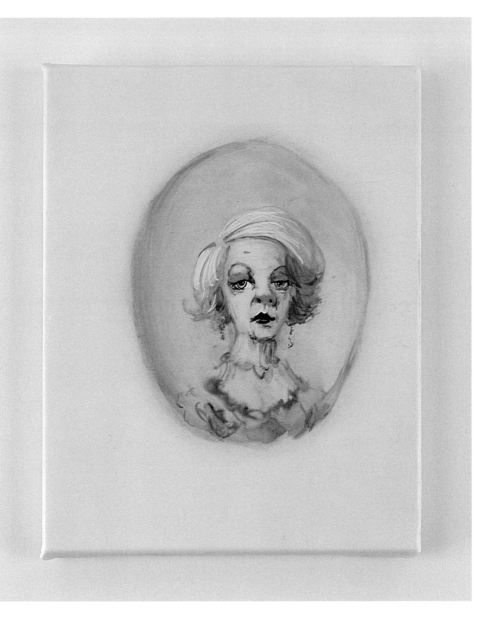

Well, what did you expect, a career in IT? Not really me, is it, stuck at a screen all day while my arse spreads over a chair like some sluggish, insidious fungus. You can't stand there by the way; you're blocking the back passage. Bad joke. Come in and shut the door. No point rolling your eyes at the state of the place. I'd have preferred something a bit more salubrious myself. Don't waste your breath on morality; only the rich can afford to be high-minded so that's no longer an option. You must realise this is just a stopgap. Wouldn't catch me doing the unsocial hours to feed a brat, or a habit with nothing to show for it but a new set of track marks in an interesting location. You do underestimate me but what's new. And maybe — but don't for a minute think I hold it against you — maybe I just thought to myself: Okay, so how lowdown can you go? Well, that red light's my cue. We're really quite high-tech around here. Can you find your way out?

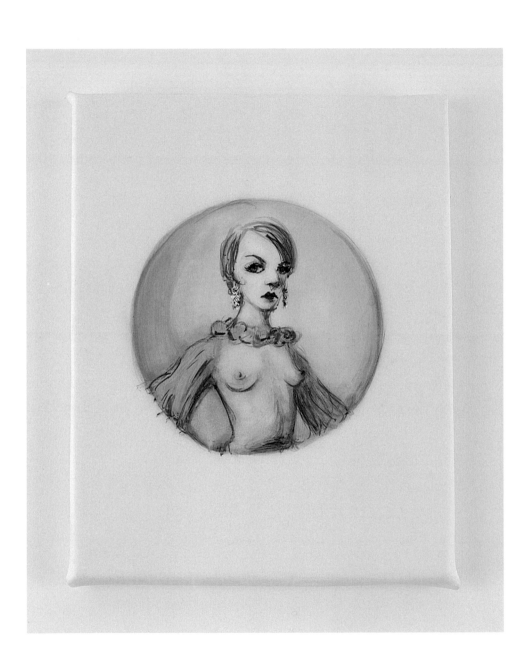

The French existentialist has left the locale, abandoned his diet of days at the library, his ponderous, thought-laden strolls. He no longer stops to enquire about the sex life of neighbourhood cats; no longer contemplates the sinuous ramblings of clematis, the disintegrating fence; no longer, at inordinate length, considers turnip, beetroot, okra, the dark-eyed boredom of the greengrocer's daughter; no longer stands in the dark, constructing hypothetical definitions of lives in lit windows; no longer postulates a theory about why encounters with blossom, leaves, mud, snow don't make him feel more at home.

The French existentialist has returned to Lille, Lyons, Lavigny. A faint smell of anise hangs in his cluttered, dusty room. Daily, he takes his thoughts to the river, the lake, the canal. He pulls them from his pocket, his crumpled thoughts, throws them in the air and waits for them to settle amidst familiar blossom, leaves, mud, snow.

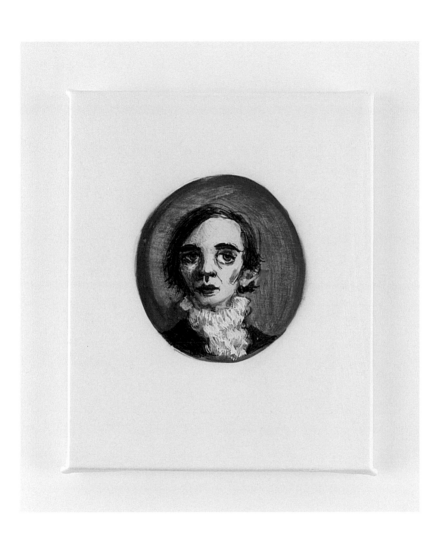

It was when she was shelling peas that she broke. She'd been sitting on a bench in the allotment, the warm sun on her face, sated bees buzzing around drunkenly, the smell of baked earth and fruition, the peas glossy as pearls between her fingers as she scooped them out of their pods. The big glass bowl must have been nearly full when she raised it above her head and tipped out the contents. The peas bounced and rolled. Some snagged in her hair. One or two found their way into her mouth – she spat them out. The others, which came to rest around her feet, she stamped on, as if they were slaters or slugs. After she'd mashed them all, she began slamming the bowl against her head like she was trying to mash it too. When blood gushed from her nose and mouth, the wardens took her off to the medical wing. She doesn't get gardening duties any more; too many opportunities for self-harm. But she liked to see things grow, liked it more than anything. Down the drills, she'd walk between cabbage and caulis, and stroke new tendrils of climbers as if they were tiny, curled up hands. One lost baby could turn anybody's head to mush, but twins? Mother of God.

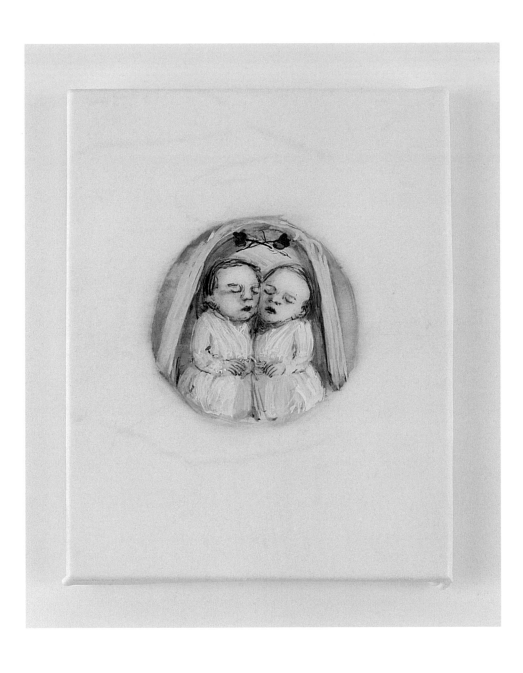

— The weather is permissive today, he said, licking his lips. That leftover summer heat, the heavy sky incubating a storm. It is especially sympathetic to gluttony, lust and sloth. Pride, in its place, perhaps. But envy, avarice and wrath should be kept under wraps.

Drops of warm rain prickled the skin of the pond where fat carp rose, dipped back into the water and found a new place to come up for air.

After a lunch of slippery dumplings, salty cheese and young wine as brown and frothy as the Danube, he sat at the piano, played a Chopin Mazurka and a Joplin Cakewalk. Stiffly. Stumbled over the tricky bits. I stood at a tall window, peeling a peach. Outside, leaves glittered like pirate gold. Lightning tore through a pewter sky.

When rain streamed down the glass and blurred our view of the elemental orgasm, we retired to his chamber for a game of what he insisted on calling *Hunt the Sausage*. After, we slept until nightfall.

When I had to leave, he didn't even consider getting out of bed. Just flicked his eyes open, closed them again. Waggled three fingers. Smiled. Smudged lipstick bled into the creases around his mouth.

It was still pouring when I drove down the long, curving avenue of sodden lime trees. The wipers beat madly, like the wings of a trapped bird. I've never been back.

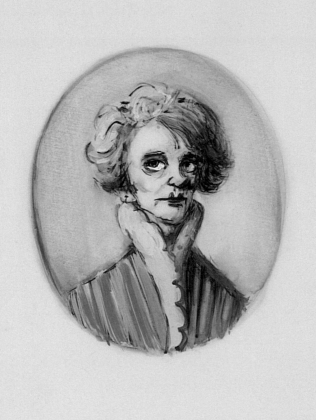

Giselle sniffs at the mention of flamenco: it's too hot and bothered for her taste, too extravagant, too *Latin*. Tap might be frivolous but flamenco — she sets her chin against late nights, loose morals and questionable men in tight trousers and approaches a shelving unit stacked with salmon pink *pointes*.

For each bright-eyed girl fidgeting on the lilac banquette of the dancewear shop she has tyrannized for thirty years, Giselle deliberately plucks out a whole shoe size smaller than requested. As the girls crush their toes against the blocks and wince as they rise into first and then second position, Giselle insists that she has fitted them all correctly.

— You have to suffer for art, she says, without a shred of pity.

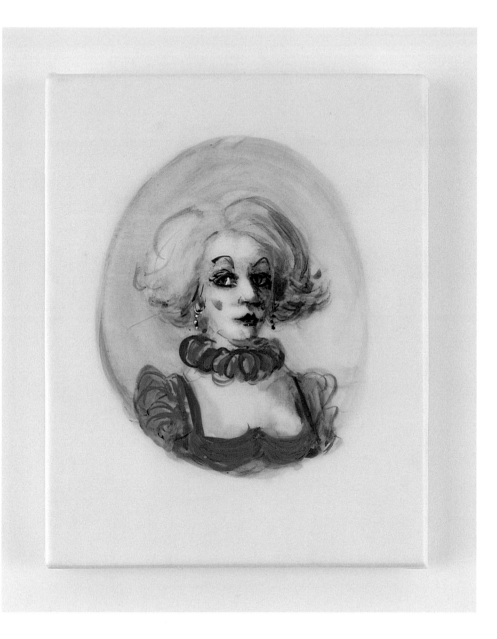

MOYNA FLANNIGAN

1963

Born in Scotland

1985

BA Honours, Edinburgh College
of Art

1987

MFA, Yale University School of
Art, USA

Currently lecturer in painting at
the Glasgow School of Art

Lives and works in Edinburgh

SOLO EXHIBITIONS

2003

Knucklehead, Sara Meltzer Gallery,
New York

2002

I'm a stranger here myself, doggerfisher,
Edinburgh

I think about it almost all the time,
Sara Meltzer Gallery, New York

2001

I could be happy with you, Galerie
Akinci, Amsterdam

2000

Galerie Albrecht, Munich

1998

Lotta Hammer Gallery, London

When People Like Us Meet People Like You,
Project Room, The Collective
Gallery, Edinburgh

1997

The British School at Rome

1996

Centre for Contemporary Arts,
Glasgow

1994

William Jackson Gallery, London

1993

Denude, The Collective Gallery,
Edinburgh

1990

The Visible Presence, Aberdeen Art
Gallery, Aberdeen

New Paintings, 369 Gallery,
Edinburgh

2004

The Drawing Project, Vamiali's Gallery, Athens

Solar Lunar, doggerfisher, Edinburgh

2003

Rendered, Sara Meltzer Gallery, New York

The Company We Keep, Inman Gallery, Houston, Texas

Moyna Flannigan, Gerben Mulder, Elke Krystufek, Ronald Versloot, Akinci Gallery, Amsterdam

Hitch, Glasgow Print Studio

Love Over Gold; Works from the Collection of the Scottish National Gallery of Modern Art, Gallery of Modern Art, Glasgow

2002

New, Green on Red Gallery, Dublin

New: Recent Acquisitions of Contemporary British Art, Scottish National Gallery of Modern Art, Edinburgh

2001

Beuys to Hirst: Art Works at Deutsche Bank, Dean Gallery, Edinburgh

Here and Now: Scottish Art 1990-2001, Dundee Contemporary Arts

Open Country: Contemporary Scottish Artists, Musée cantonal des Beaux-Arts de Lausanne, Switzerland

2000

Annäherung an das Portrait: Moyna Flannigan, Konrad Klapheck und Monica Castillo, Galerie Albrecht, Munich

Moyna Flannigan & Chantal Joffe, Galerie Akinci, Amsterdam

1999

The NatWest Art Prize 1999, Lothbury Gallery, London

Galerie Akinci, Amsterdam

Locale, City Art Centre, Edinburgh

This Was Now, The Travelling Gallery

1998

Family Credit, The Collective Gallery, Edinburgh

This Island Earth, An Tuireann, Isle of Skye

1997

9th Oriel Mostyn Open, Llandudno

Torri D'Avvistamento, Palazetto
and Tower of Spirito Santo,
Tarquinia, Italy

Kolme Skotlannista, Kajaani Art
Museum, Finland

1996
Rear View, The Collective Gallery,
Edinburgh

1995
Everyday Stories, Ikon Gallery,
Birmingham

SELECTED AWARDS

1999
Finalist, The NatWest Art Prize

1997
The Scottish Arts Council
Scholar, The British School at
Rome

1996
Hope Scott Trust Award

1994
Artists' Award, Scottish
Arts Council

1990
Artist in Residence, Aberdeen
Art Gallery

1985–6
Yale University Scholarship

1984
Ellen Battell Stoeckel Fellowship,
Yale University Summer School of
Music and Art

COLLECTIONS

Aberdeen Art Gallery

Arts Council of England

Arthur Andersen & Co, London

City Art Centre, Edinburgh

City Art Collection, Munich

Deutsche Bank

Fleming's Bank, London

NatWest Art Collection, London

Progressive Corporation, USA

Saatchi Collection, London

Scottish National Gallery of
Modern Art, Edinburgh

Spencer Stuart, London

BIBLIOGRAPHY

— Christopher Chambers, 'Moyna Flannigan', *Flash Art*, July – September 2003, p.67

— Rachel Devine, 'New, Recent Acquisitions of Contemporary British Art', *Sunday Times*, 30 June 2002

— Alice Dewey, *New: Recent Acquisitions of Contemporary British Art*, Scottish National Gallery of Modern Art, Edinburgh, 2002

— Iain Gale, 'Strangers to Convention Who Are All Dressed Up With Nowhere To Go', *Scotland on Sunday*, 1 September 2002

— Keith Hartley, *Locale*, City Art Centre, Edinburgh, 2001

— Angela Kingston, *Moyna Flannigan*, Centre for Contemporary Arts, Glasgow, 1996

— Neil Mulholland, 'Moyna Flannigan', *Flash Art*, November – December 2002

— Caroline Nicod, Francis McKee and Rob Tufnell, *Open Country: Contemporary Scottish Artists*, Musée cantonal des Beaux-Arts de Lausanne, Switzerland, 2001

— Lucy Sweet, 'Secret Lives of Odd Faces', *Sunday Times*, Edinburgh Festival supplement, 18 August 2002

— Rob Tufnell and Katrina M. Brown, *Here and Now: Scottish Art 1990–2001*, Dundee Contemporary Arts, Dundee, 2001

DILYS ROSE

Dilys Rose was born and brought up in Glasgow. She has travelled widely and was employed in a variety of occupations at home and abroad, though Edinburgh has been her home for many years. She is currently writer in residence at the University of Edinburgh where she teaches on the recently established course in creative writing.

Dilys Rose has published three collections of short stories, three of poetry – most recently *Lure* – and a novel, *Pest Maiden* and has recently completed a new collection of stories. She has received various awards for her writing including: The Macallan / *Scotland on Sunday* Short Story Prize, The R.L.S. Memorial Award, The Society of Authors' Travel Award, The Canongate Prize and two Scottish Arts Council Book Awards. Her second collection of stories, *Red Tides*, was short-listed for both the McVities' Scottish Writer of the Year and the Saltire Scottish Book of the Year. *Pest Maiden* was nominated for the Impac Prize.

www.dilysrose.com